TOMBS AND MONUMENTS

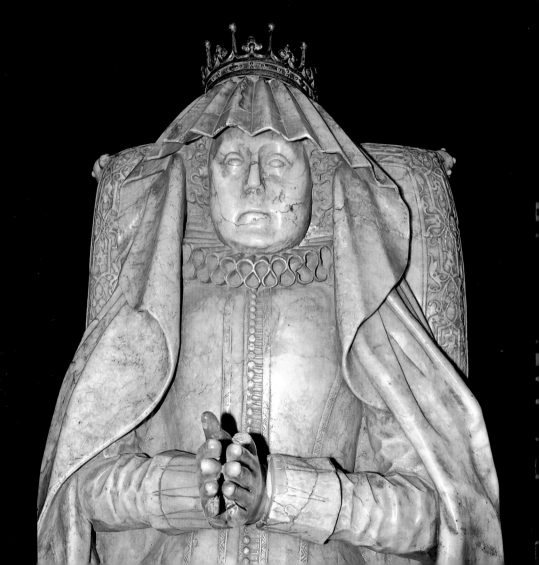

A Little Book

of
Tombs And Monuments

Text and Photography by

Mike Harding

Aurum

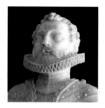

First published by Aurum Press Ltd.
7 Greenland Street, London NW1 0ND
www.aurumpress.co.uk

Text and photography © 2008
Mike Harding

A catalogue record for this book is available
from the British Library.

ISBN 978 1 84513 306 1

Printed in China

Facing title page – Appleby, Cumbria
Title Page – Swinbrooke, Gloucestershire
Above – Exton, Rutland
Opposite – Stanton Harcourt, Oxfordshire

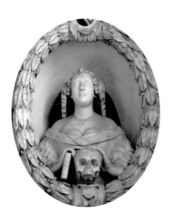

Stele and shattered columns, urns and cherubim,
Angels with broken wings and moss crowned heads,
Weepers and laurel wreaths, pyramids and mausoleums,
Enough stone for a city – and here the city is –
Row on row, and street on street, a city of the dead.

From 'In The Necropolis', *by the author*

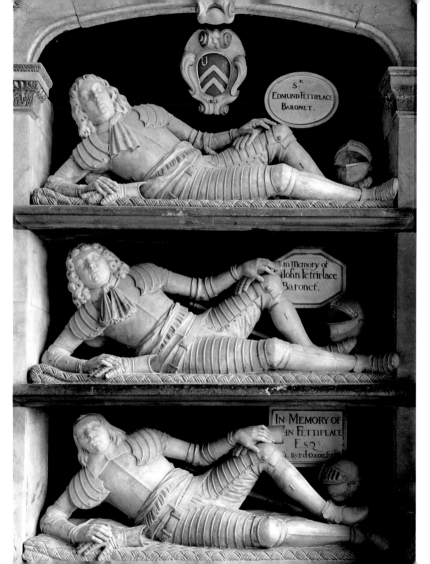

INTRODUCTION

Here as ever in sleeping sound
Lies our Audrey in the ground.
If she rise as rise she may,
There'll be fun on Judgement Day.

Anon – On a tombstone in Corofin, County Clare, Ireland

❖

From the very earliest times it seems that people came to associate sacred places with a better life in the hereafter, and therefore chose to be buried as close as they could to the inner sanctum. So it is that around great monuments like Stonehenge and Avebury you will find clusters of prehistoric burial mounds spanning thousands of years.

When Christianity came to these islands the tradition continued, and now, in the great abbeys and cathedrals, you will find the same story, with the rich and powerful, the chosen of God (as they saw it) making sure they were

buried as close as possible to the high altar. All the great marble and alabaster tombs in this book, including the triple-decker tomb on the previous pages from Swinbrooke, Gloucestershire, were found in the chancels of the churches, close to the altar.

In this way, from the earliest marble tombs of the great, like the one here from Nantwich in Cheshire — to the death's head from Cartmel,

Lancashire, on the previous page — men and women have sought to leave a marker of their days on the earth, hoping to stay the obliterating hand of time. In some cases the tombs and monuments made for the dead are quite beautiful and often deeply touching in sentiment; the monuments to children in particular.

Britain is unique in its collection of tombs and, though the iconoclasts of the Protestant Reformation and Cromwell's Revolution robbed us of immeasurable treasures in stained glass, paintings and carvings, apart from lopping off a good number of noses and hands, the Christian Taliban left many of the great tombs and monuments alone, perhaps because they mostly commemorated the ancestors of the wealthy and powerful.

So it is that, from the great cathedrals to the smallest medieval

parish church, these islands hold an unparalled collection of alabaster and marble tombs. The alabaster, of which many of the finest tombs in England were made, came mainly from Nottinghamshire, where there was a rich seam of the very best stone.

Nottingham alabaster made its way all over Europe and was used for the finest carvings.

Sometimes the artistry of the makers is breathtaking and all we can do is marvel and wonder how quarried stone could be cut so finely. There were no pneumatic tools to take off the first skins of stone then, and the carvers worked for months with simple hand tools,

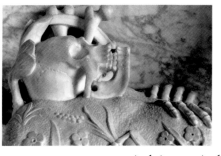

nibbling away at the alabaster and marble. Look, for example, at the image here, from Great Mitton in Lancashire, of a skeleton, seemingly clawing its way out of the flower-strewn earth.

As well as being commemorated in alabaster and marble, the dead were remembered in stained glass, and, during the Victorian period in particular, the wealthy bereaved turned from alabaster and marble to great glassmakers to fix the names of the dead in the minds of the living. In glass and stone, wood and mosaic, the craftsmen, in the name of the dead, brought to life some of the greatest art of western Europe.

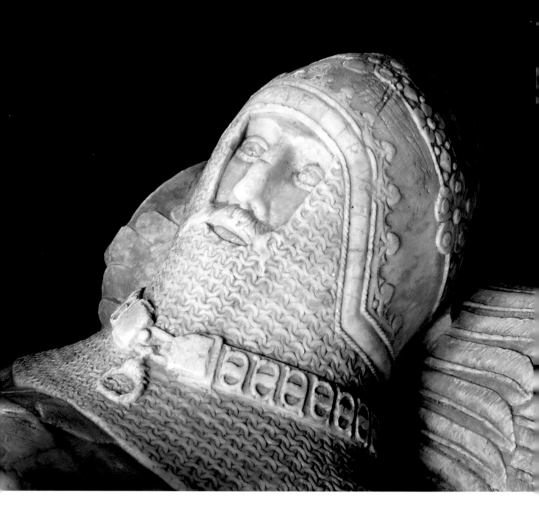

LORDS AT REST

❖

West Tanfield, Yorkshire & Much Marcle, Herefordshire

West Tanfield's small but handsome parish church contains one of the finest tombs in the north of England. Two alabaster figures represent Sir John Marmion and his wife, Elizabeth. Sir John, opposite, died in Spain in 1386 fighting for his lord, John of Gaunt, the original Lancastrian. The chain around Sir John's neck shows his allegiance. The tomb on this page is a fourteenth-century wooden effigy in quite an amazing condition. Such wooden monuments are quite rare; the Much Marcle monument, life-sized and carved from a single block of oak, commemorates Sir Walter de Helyon, about whom little seems to be known.

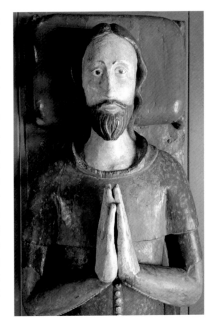

LADIES AT REST

❖

Exeter, Devon & Ludlow, Staffordshire

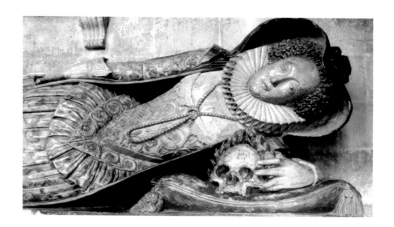

Symbolising the soul at rest awaiting resurrection, the reclining figure above, from Exeter, of Lady Dodderidge is a perfect example of a wealthy Elizabethan lady in all her finery. Note the skull with the victor's laurels representing the victory of Death. On the facing page, a kneeling Jacobean gentlewoman, Elizabeth Waties, looks across at her husband, Edward, on a fine monument in St Leonard's, Ludlow.

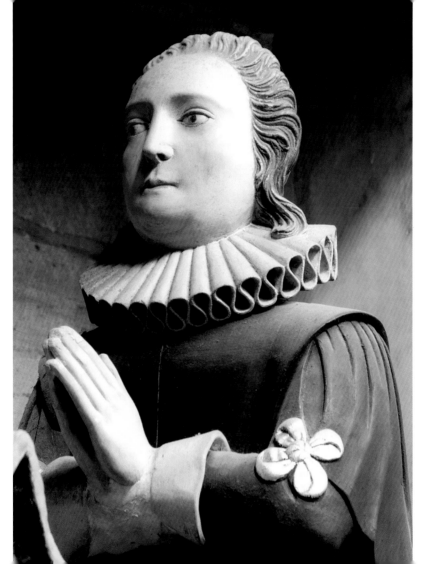

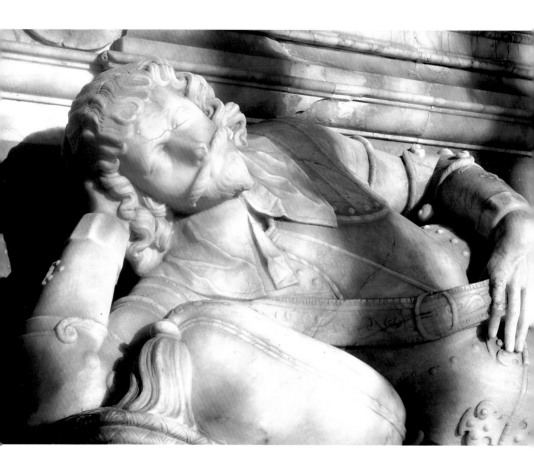

THE DRURY TOMB

Besthorpe, Suffolk

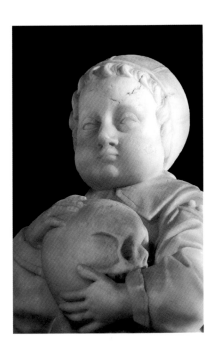

L ondon's famous theatre street, Drury Lane, gets its name from the gentleman opposite, whose estates brought him great wealth but no escape from the Grim Reaper. His fine alabaster tomb lies by the altar in the small but lovely church at Besthorpe. On the day I visited, the sun shone in through the south windows of the chancel, striking the tomb, and picking out not just the handsome features of Sir John Drury but also those of his children, who kneel at his feet. The little girl on this page, one of three children at the foot of their father, holds a skull to signify that she pre-deceased him.

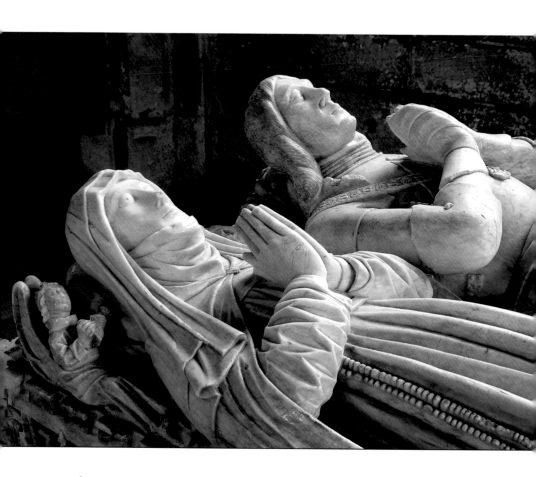

BEDESMAN AND HIS PATRONS

Harewood, Yorkshire

Harewood Hall, one of the great stately homes of England, has its own chapel, half hidden in a copse of trees on the edge of the estate. The tombs of the ancestors of the present Lord Harewood lie in the depths of the church, fascinating examples of the finest of English alabaster

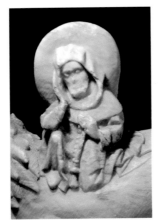

work. The little bedesman here lies at the foot of William Redman, and his presence indicates that the departed knight left money to endow a chantry. There, bedesmen and their rosary beads would be employed to pray for his soul, winning him, by their prayers, relief from the torments of purgatory, the half-way house for those whose sins were not serious enough to earn them a place in hell, but bad enough to keep them out of paradise, until enough prayers or masses had been said to move them upstairs.

THE WORTHY DEAD

❖

Preston on Stour, Warwickshire & Tombland, Norwich

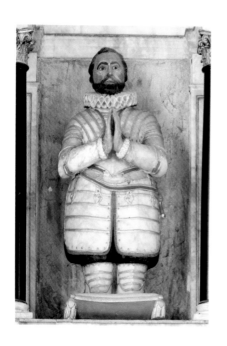

Stilled by death, they look out at us through the ages, or stare into each other's eyes across a *prie dieu*, their children ranged behind them. In an age of certainty there was never a doubt but that the dead would rise, re-corporate in all their parts and (in the case of the wealthy and worthy) in all their finery. The monument opposite, a particularly lovely Elizabethan piece, is hidden behind the organ at St George's, Tombland and commemorates Thomas Anguishe, his wife and their ten children. The rosy-cheeked Tudor grandee here looks out into the chancel of the lovely little church at Preston on Stour.

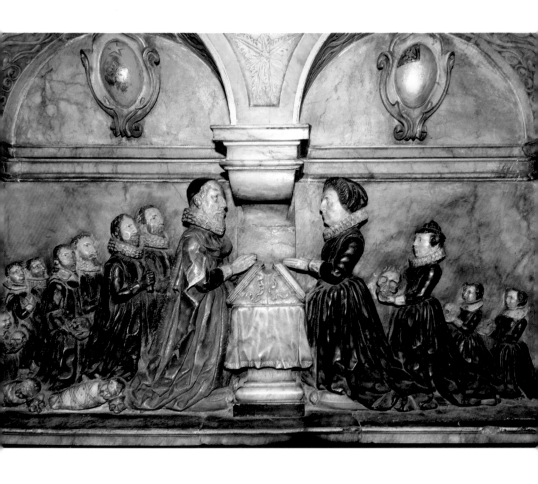

THE SUCKLING MONUMENT

St Andrew's, Norwich

Norwich must have more medieval churches within its walls than any other city in these islands. Sadly many of them are now converted to other uses, but a fair number remain open, amongst them the great church of St Andrew's. In the chapel in the south aisle is a small group of fine monuments, the finest, in my opinion, being that of Sir John Suckling and his wife, Martha, shown opposite. Suckling was mayor of Norwich for a time and was also treasurer to James I. That such power and wealth should be concentrated in a small city so far from London seems strange until we remember the wool trade, and how the fur from countless sheeps' backs paid for many of the great churches of Norfolk and Suffolk, Lincolnshire and Yorkshire. Note the cherub in one corner and Old Father Time in the other representing birth and death. By the way, there is, as far as I know, not one monument to a sheep anywhere in Norwich.

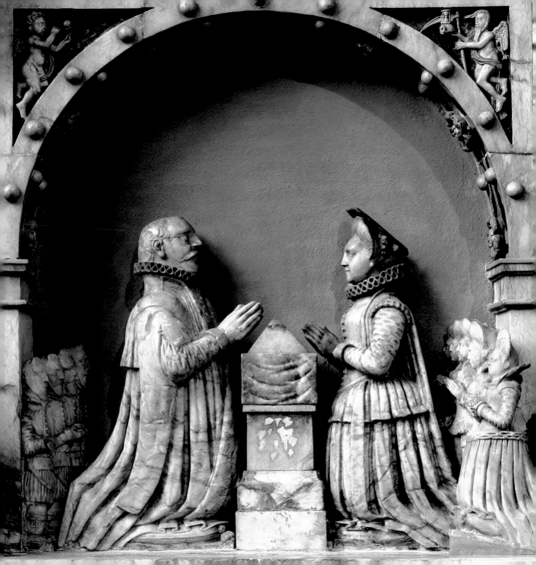

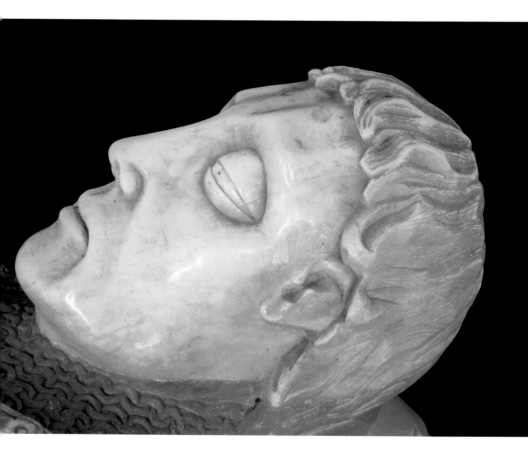

ALABASTER AND PAINT

Broughton, Oxfordshire

With his pod-like eyes and stylised hair, the knight on the page opposite has lain on his alabaster slab at Broughton for the last six hundred years. St Mary's Church stands in farmland close to Broughton Hall. It contains six centuries of tombs and hatchments including the fifteenth-century tomb of Sir Thomas Wykeham on the page opposite, and, on this page, what is possibly the most richly decorated medieval tomb in England, beneath which lie the bones of Sir John de Broughton (d. 1315), who founded the church. Two lovely painted angels are doing their best to haul the dead knight heavenward.

A NOTTINGHAM PHOENIX

❖

Taos, New Mexico

It's a long way from the coalfields of Nottingham to the hills above Taos, New Mexico, but that is where the writer D. H. Lawrence has his mausoleum. The open door of his simple whitewashed tomb looks out towards the Sangre de Christos mountains, while the altar, designed by Lawrence, was built, according to legend, with a mortar mixed with his ashes. An alcove holds a silver phoenix, a symbol that had a special importance for Lawrence; the soul rising after death as the phoenix of mythology is said to rise from the ashes.

Close by the mausoleum is the Kiowa ranch where Lawrence spent several years, where he wrote *Mornings in Mexico,* and where people like the artist Georgia O'Keeffe were regular visitors. Outside Lawrence's tomb is the far plainer grave of Frieda Lawrence, his wife, with little on it but her name and the cameo here.

ELOQUENT SIMPLICITY

Melbourne, Derbyshire & Briggflats, Cumbria

There is something elegantly beautiful about the simple tablet on this page, found close to the altar in Melbourne Parish Church. A short story of a life cut short by war, beautifully lettered. Simplicity in another form can be found in the plain tablet

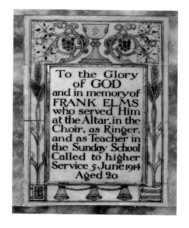

facing, dedicated to one of our greatest poets, Basil Bunting. His major work, *Briggflatts*, is a love poem spanning fifty years, celebrating his love for Peggy, the blacksmith's daughter at Briggflats and his love for the hills and mountains of Cumbria and Northumberland. The poem is as filled with the craggy cadences of the north as the fells are with rocks and water; to hear Bunting read the poem on tape is to understand how great a music there is in the spoken word, as his singing, northern voice incants, 'By such rocks men killed Bloodaxe!'

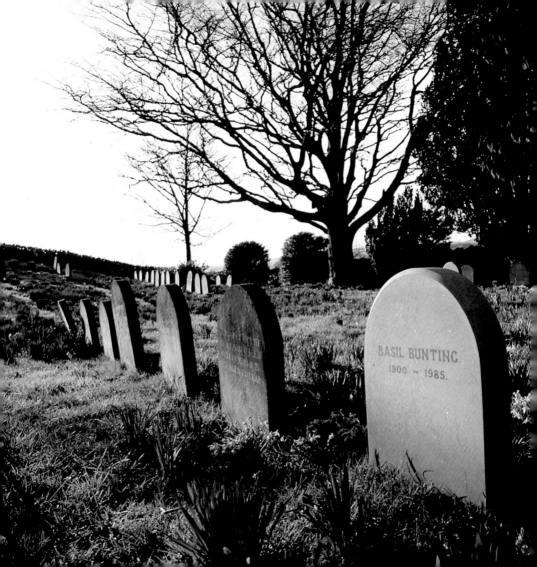

THE VAINGLORIOUS DEAD

❖

Grantham, Lincolnshire & Exton, Rutland

In contrast to the simplicity shown on the preceding pages, Lord Lonsdale (of boxing belt fame) stands, on the page opposite, a Roman Emperor on a massive monument, ornate to the point of decadence. The work, by Grinling Gibbons, is just one of several fascinating pieces in Exton's well-loved parish church. Over the years, bits of Lord Lonsdale and his lady have come amiss and been displaced, often by cleaners who then threw the pieces 'out back'. Searches for fingers and other items 'out back' have so far not come up with anything, so the good lord is still incomplete – *Sic Transit Gloria Mundi.* The medallion on this page, from Grantham, is part of a very fine tomb commemorating Baptist Noel, Lord Viscount Campden. The wig, in particular, is a very intricate piece of work.

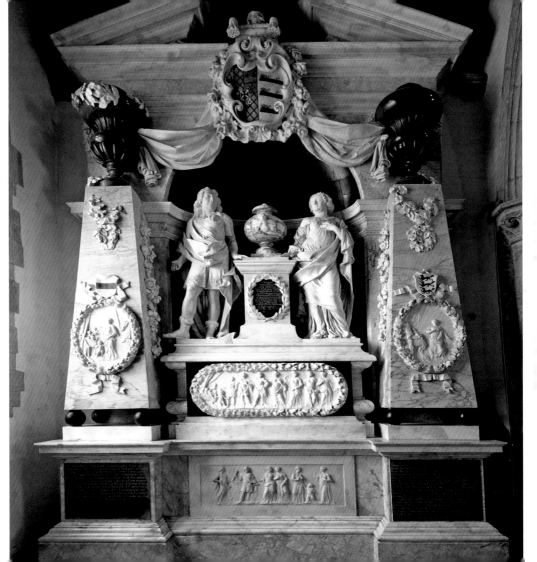

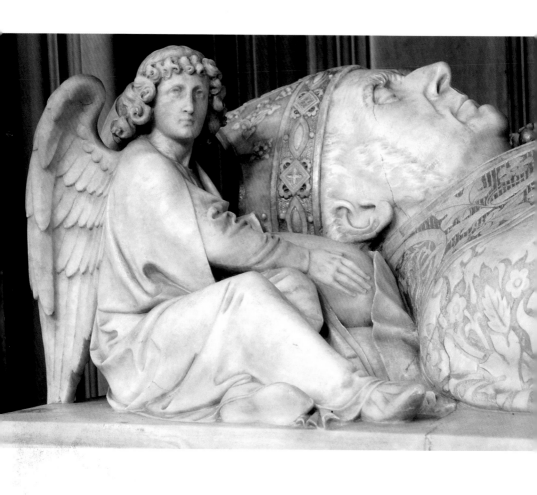

PRIESTS AND ANGELS

❖

Ely, Cambridgeshire & Wirksworth, Derbyshire

Wirksworth, a small town in Derbyshire, has one of the finest parish churches in the county, with some wonderful Victorian glass and Saxon carvings, including the stone tomb lid on this page,

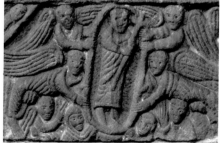

which once covered the remains of a Saxon priest. In the carving, angels carry a dead priest (possibly a bishop with his crozier) to Paradise, still in his coffin.

On the page facing, from Ely, an angel sits by the head of Bishop Woodford. Angels accompanying the dead were a common theme for the monumental mason, and this little chap opposite,

with his curly locks, is typical of the angels that guided Victorian worthies on their journey into the beyond.

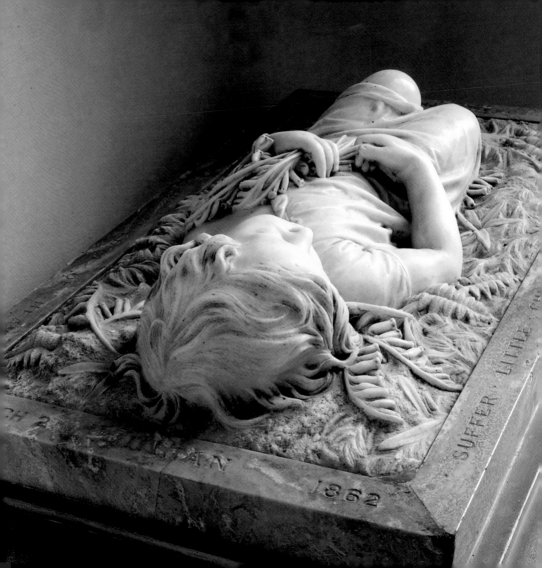

SUFFER THE LITTLE CHILDREN

Nuneham Courtenay, Oxfordshire & Narborough, Norfolk

After many years of crawling around churches taking thousands of photographs and notes, I am still not hardened to the sight of children's tombs and memorials. Bad enough that those of us who've had a fair innings are walking far too quickly down the lane towards the very Grim Reaper, it seems beyond all calls of natural justice that little ones should be whisked away into the dark. It was

once thought that, because infant mortality was so high in years gone by, parents did not get close to their children. Diaries and journals as well as tomb and monument inscriptions show this to be wrong. Julian Harcourt, opposite, who died aged two at Nuneham Courtenay, and the baby here from Narborough, were sorely grieved for and deeply missed.

THE DEATH'S HEAD

❖

Burton Agnes, Yorkshire & Wirksworth, Derbyshire

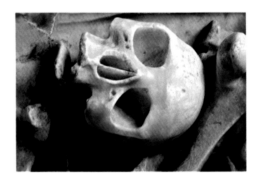

Skulls and cadavers, winding sheets and worms, all served to remind both rich and poor that 'from dust we come and to dust we will return.' The Black Death underlined this, so that by the time many of the great alabaster tombs were being built, the death's head, as a symbol of mortality, had come to be a common theme. The skull on this page can be found on a tomb in Burton Agnes Parish Church. The death's head from Wirksworth, opposite, wears the victor's laurels, showing the eventual triumph of death over life.

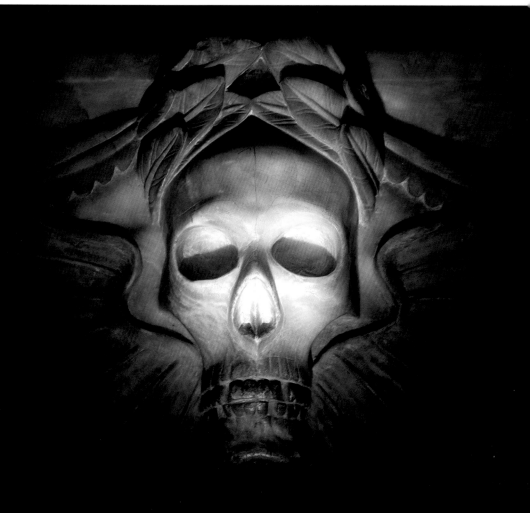

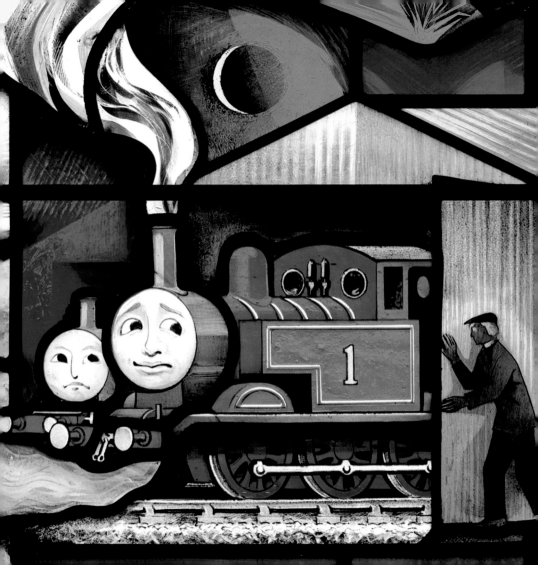

In Memoriam Two Vicars

Rodborough, Gloucestershire & Edgefield, Norfolk

St Mary Magdelene's church, Rodborough, has a stained glass window that steam buffs of all ages everywhere will recognise. The window celebrates the life of the Rev. W. Awdry and his wife. Awdry created one of the most well-known little chuffers in the world, Thomas

the Tank Engine, seen here with (I think) Percy, two of the characters in the famous series of railway books that have given so many children all over the world such joy.

The pedalling parson, on this page, with his round, domed hat, must have been quite a character too; Canon Hubert Marcon, who was rector of Edgefield from 1875 to 1937, tells us 'I have ridden every lane high and low, with tyres wooden, solid and pneumatic'.

TWO DORSET HEROES

❖

Sherborne Abbey, Dorset & Wareham, Dorset

Jimmy, he is called, the anonymous hero on this page who lies dead somewhere in the mud of the Somme, 1916. This beautiful memorial by Martin Turner is made from sycamore and black walnut; the helmet is carved

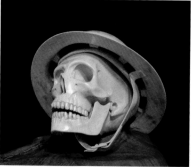

from a single piece of wood. Jimmy stares sightlessly out from the past, a memorial to the bravery of all who fell in that terrible battle. T. E. Lawrence (Lawrence of Arabia), the hero of the desert campaign against the Turks in World War One, and author of *The Seven Pillars of Wisdom*, died in a motorcycle accident not far from Sherborne. The memorial facing, carved in his honour by Eric Kennington, was offered to both Westminster Abbey and Salisbury Cathedral but they refused to house it — perhaps because of Lawrence's sexuality. It has a home now in the tiny Saxon church of St Martin's, Wareham.

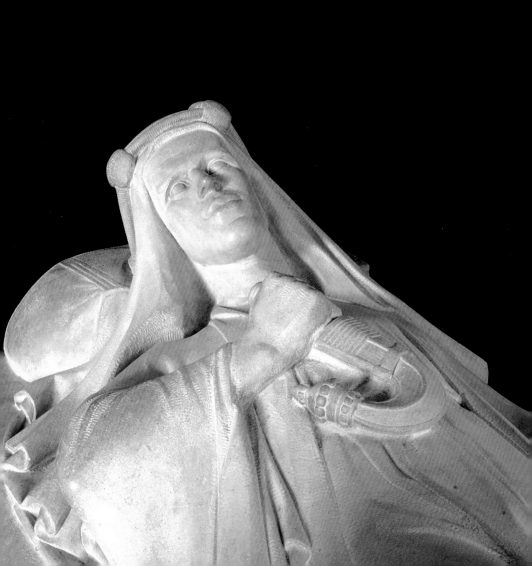

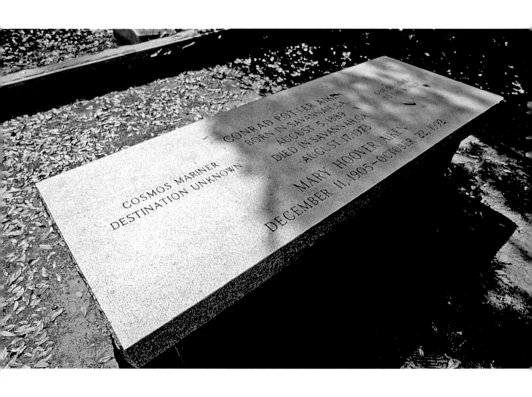

CONRAD POTTER AIKEN
BORN IN SAVANNAH GA
AUGUST 5, 1889
DIED IN SAVANNAH GA
AUGUST 17, 1973

MARY HOOVER AIKEN
DECEMBER 11, 1905 – OCTOBER 22, 1992

COSMOS MARINER
DESTINATION UNKNOWN

COSMOS MARINERS

❖

Bonaventure Cemetery, Savannah, Georgia, USA

Bonaventure Cemetery, Savannah, Georgia, is a place of high trees and Spanish moss; acres of tombs and monuments stretch as far as the eye can see on the swampy edges of the Savannah River. Every evening at sundown, the poet Conrad Aiken would come to the cemetery to watch the day die, bringing a thermos with a ready-mixed cocktail. Aiken loved to look at the great ships moving up and down the river, and would later try and find out where they

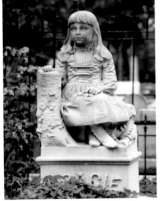

were bound. One evening he saw an interesting-looking ship heading for the sea and, when he looked in the shipping list of the local paper that night, he read, 'Cosmos Mariner – destination unknown'. He chose those words for his epitaph. Little Gracie, her memorial sadly realistic, lies close by. Nobody seems to know the story of Grace, only that she went on her own cosmos journey tragically young.

THE WAR TO END WARS

Swaffham Prior, Cambridgeshire

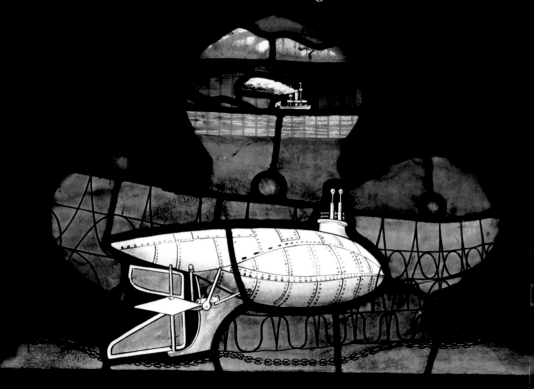

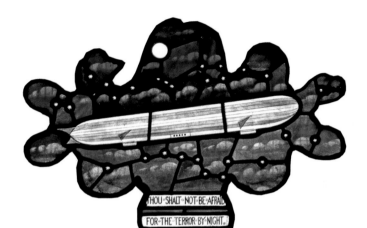

THOU·SHALT·NOT·BE·AFRAID

FOR·THE·TERROR·BY·NIGHT.

Swaffham Prior has one of the most touching sets of memorial windows I have seen. Almost naive in execution, the windows, commemorating the Great War of 1914-18, show the war in the air, on land and at sea, as well as marking the contribution of hospital and munitions workers. The windows also show the return to peace after the carnage. Each panel carries a biblical quotation fitting to the image. On the facing page, a U-boat preys on shipping; on this page a Zeppelin flies over England. On the following pages, a German biplane soars through the heavens, and a signals tent with poles and aerial wires stands under a looming, stormy sky.

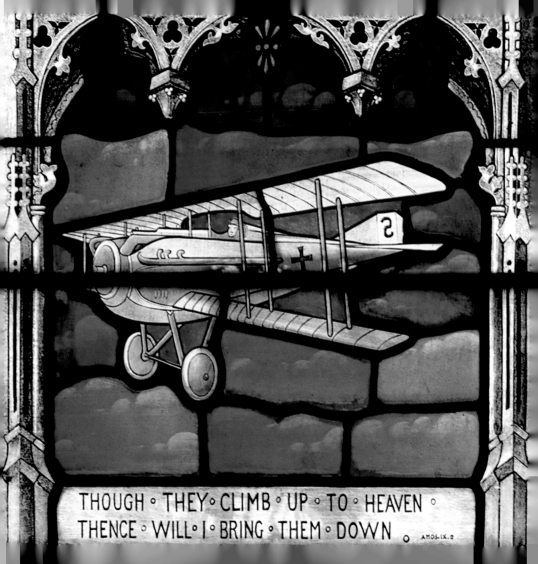

THOUGH · THEY · CLIMB · UP · TO · HEAVEN ·
THENCE · WILL · I · BRING · THEM · DOWN AMOS·IX·2

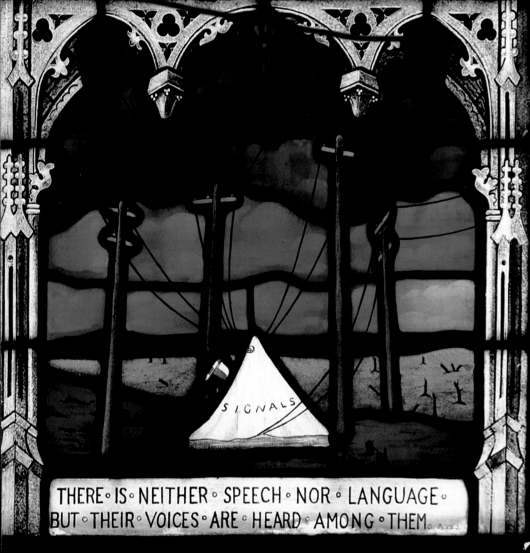

SIGNALS

THERE·IS·NEITHER·SPEECH·NOR·LANGUAGE·
BUT·THEIR·VOICES·ARE·HEARD·AMONG·THEM

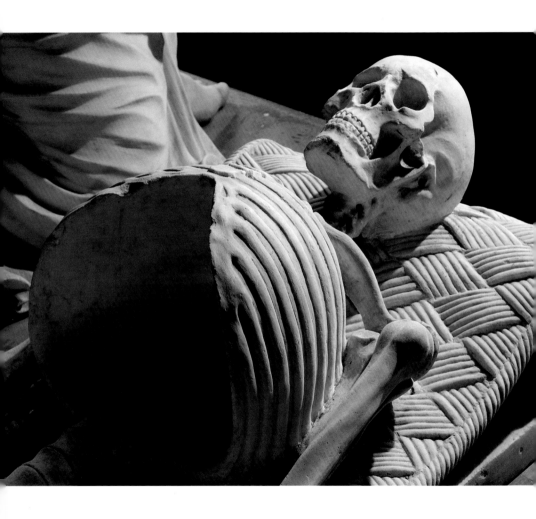

CADAVER TOMBS

❖

South Dalton, Yorkshire & Ousden, Suffolk

Cadaver tombs reflect the obsession with mortality that followed from the Black Death, the plague which cut a swathe through Europe between 1345 and 1351. It is not known how many people died during the years of the Black Death, but estimates vary from one-quarter to one-third of the population of Europe. Some religious houses lost half their clergy, and great numbers of the aristocracy were mown down. It is not recorded what happened to the countless and anonymous poor. The fearsome cadaver on this page, from Ousden, is in its winding sheet, the top knot clearly visible. The skeleton on the facing page lies beneath the great Lord in his finery at South Dalton.

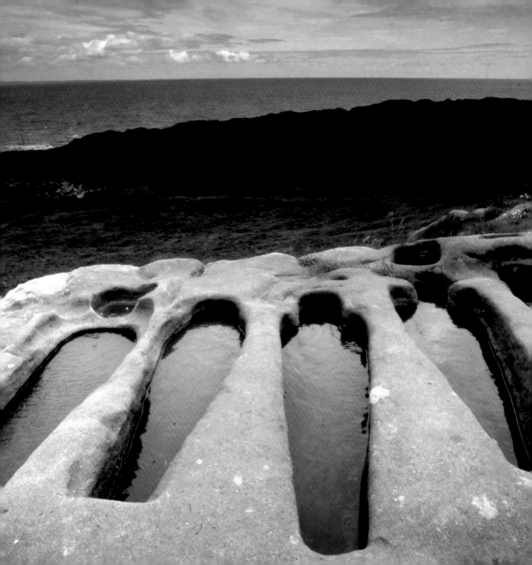

MONKS AND TEMPLARS

Heysham, Lancashire & Wensleydale, Yorkshire

Hacked into the solid rock outside St Patrick's chapel, Heysham, are the group of monks' tombs on the page facing. At one time they must have had stone lids too, but they are long gone, as are the mouldered bones of the monks that lay there. On this page you see a similar shaped tomb, though this one is far smaller. The Knights Templar, who built the tiny (now ruined) chapel near West Witton in the Yorkshire Dales, believed that all that was needed for the body to be re-made on the Day of Judgement was the skull and two long bones (usually from the thigh). That, I suggest, was all that would have been buried here in these small tombs. You can get some sense of their size from the nearby flowers of white clover; the tombs are no more than a few feet long.

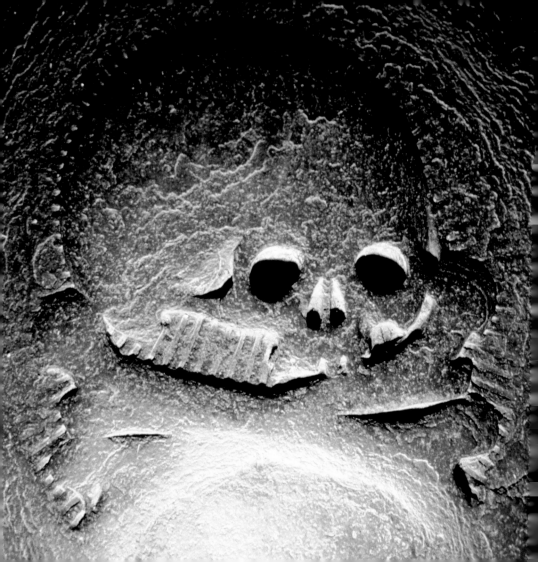

SKULL AND CROSSBONES

❖

Cartmel Priory, Lancashire

Cartmel Priory is one of the North of England's finest churches, well cared for and containing a mass of treasures: medieval stained glass, fifteenth-century misericords and a group of death's heads carved into slabs in the floor. As mentioned previously, the Knights Templars believed that all that was needed for the body to rise again on Judgement Day was two large bones and a skull. The skull and crossbones thus became one of their symbols and was flown on the flags of their ships. Since they were not averse to the odd spot of piracy – particularly against Muslim vessels – the Jolly Roger soon became the symbol of piracy, and later a hazard warning. The medallion on this page, with its winged hourglass, reminds us that time flies and death comes on speedy wings.

Local Heroes

Middleton, Lancashire

In 1513, seventeen archers went from what was then the village of Middleton (it is now a post-industrial cotton town near Rochdale) to fight with their lord, Richard Assheton, against the Scots army under James IV at the Battle of Flodden Field. Two ancient stained glass panels from the time show the archers and their lord kneeling in prayer before they left for battle. Though ravaged by the centuries,

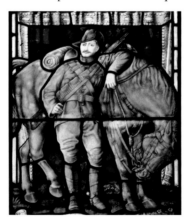

the windows are amazing. In the panel facing you can see the arrows in their quivers, and the name of each archer inscribed along his bowstave. This is the oldest stained glass memorial window of its kind anywhere in Europe. In the same church is the only window I have come across, thus far, that commemorates the Boer War. The panel here, one of three, shows one of the local mounted Yeomanry.

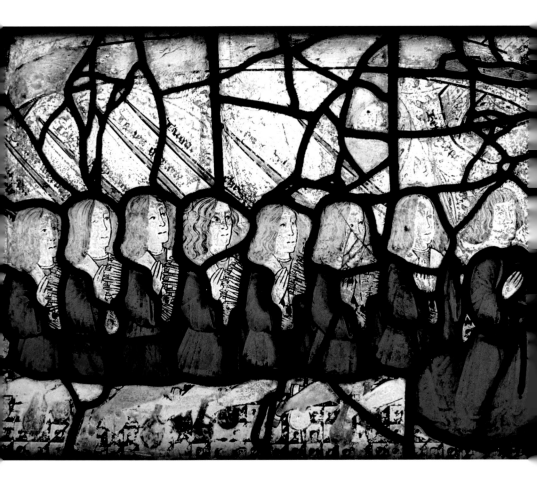

Assassinated By An Iroquois

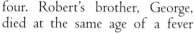

Bury, Lancashire

Sir John Franklin and his seamen died in the frozen Arctic wastes while trying to find the North West Passage that would link the Atlantic and the Pacific oceans via Baffin Bay and Alaska. On a previous Arctic expedition he had taken with him a lad from Bury called Robert Hood, who, according to the memorial in St Mary the Virgin, was 'assassinated by an Iroquois' at the age of twenty-four. Robert's brother, George, died at the same age of a fever contracted on a scientific expedition to the tropics. The monument to the brothers stands just inside the door of this most beautiful Arts and Crafts church, one of the finest of its kind in England. I particularly love the walrus that you see on this page. On the opposite side stands an elephant, the Tropics and Arctic both represented.

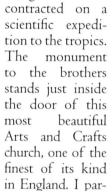

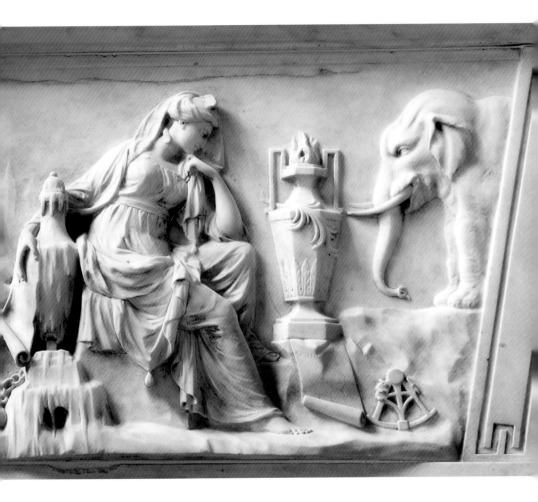

THE PITY OF WAR

Southwell, Nottinghamshire

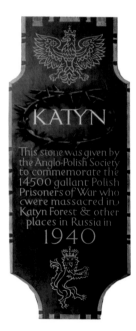

Churches all over these islands have memorials to those who fell in war; the young men and women sent by the old to die. Europe in the last century alone saw millions butchered in the two Great Wars, and every parish church, and every village green or town hall square has a monument or plaque naming the dead. In Southwell Minster there are two especially beautiful memorials: the calligraphic, slate plaque on this page is a simple reminder of the terrible massacre at Katyn. The beautiful painting, facing, by Hamish Moyles (the doors of a triptych), can be seen in the same small chapel. The dove of peace is dying on the barbed wire, vapour trails from fighter planes scar the sky, and the crows are about to feast on the dead man. The poem in the painting is *Still Falls The Rain* by Edith Sitwell.

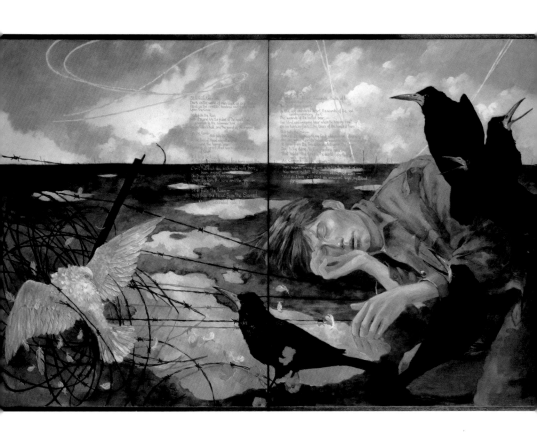

GROTESQUES

❖

Chalgrove, Oxfordshire & South Dalton, Yorkshire

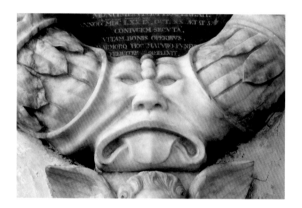

Horrors in the shape of cadavers, skulls and winged hourglasses are common enough on tombs, yet, not content with that, some tomb-makers seem to have dug deep into their own macabre imaginations while working on the monuments of the wealthy and powerful dead. On this page a tongue-pulling demon looks down from a wall in Chalgrove church. On the facing page, Justice, one of the four virtues from the Hotham tomb in South Dalton, sprouts a second head like a tiara.

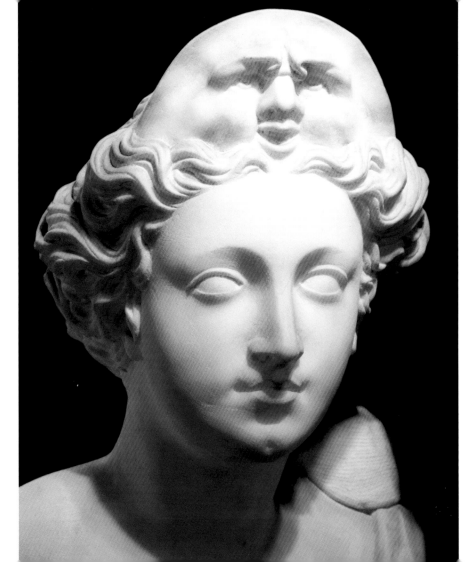

THE NOBLE DEAD AT PRAYER

St George's, Norwich & Burton Agnes, Yorkshire

Facing each other across a prayer stool, the couple here, united in death by their faith, are shown in pious pose, accepting their fate almost gladly. They can be found in St George's, Tombland, Norwich,

above a dole table on which bread used to be left for the poor, paid for from their bequest. On the facing page, Maude and Roger de Somerville, he dressed as though ready for war, she looking like a nun, kneel on cushions, hands folded in prayer. The Somervilles owned vast estates in Yorkshire and in Ireland, in County Cork. One of their descendants was the Somerville of Somerville and Ross, authors of the humorous Irish book *Memoirs of an Irish R.M.*

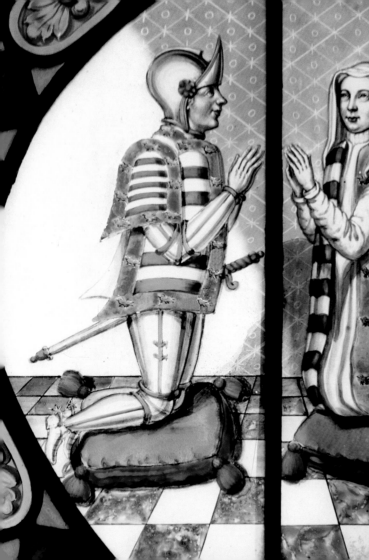
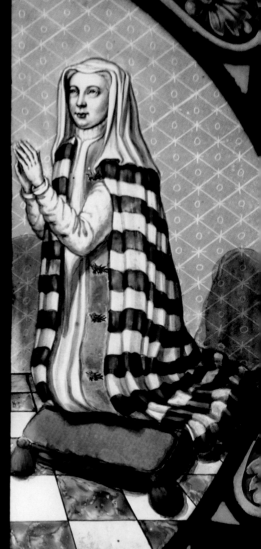

THE BEAUCHAMP TOMB

St Mary's, Warwick

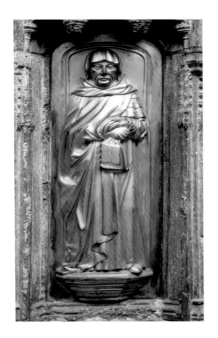

Possibly one of the finest monuments in these islands, the latten (an alloy similar to bronze) effigy of Richard Beauchamp, 13th Earl of Warwick, lies in the Beauchamp chapel, a beautiful treasure house in St Mary's Church. Beauchamp fought against Owen Glendower, capturing the Welsh warrior's banner himself. In later life he was the protector of the boy-king, Henry VI, and presided over Rouen during the trial and execution of Joan of Arc. He also made a two year pilgrimage to the Holy Land. On this page, one of the tomb niches holds a portrait of Richard Neville, 'the Kingmaker.'

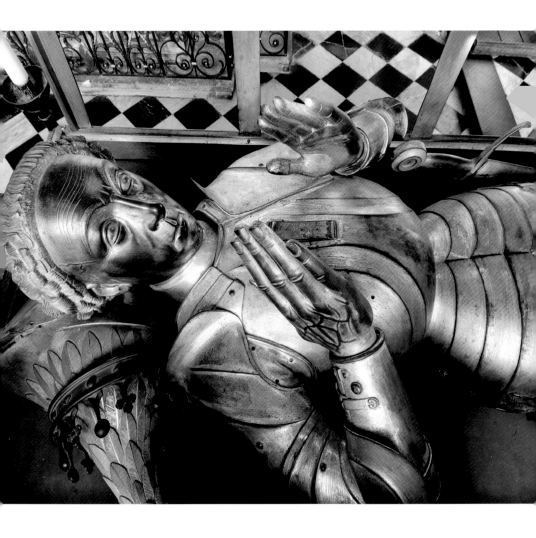

Lord Of The Hedgehogs

Much Marcle, Herefordshire

Hedgehogs (as far as I know) don't feature too much on the tombs of the great and powerful. The Kyrle tomb in Much Marcle is the exception. It has, at the foot of the great lord, a lovely little carving of a Tiggywinkle perched on a knight's helm. The hedgehog was part of the Kyrle family crest. Symbolising what? A prickly nature perhaps. The tomb was carved by an Italian artist and is quite magnificent.

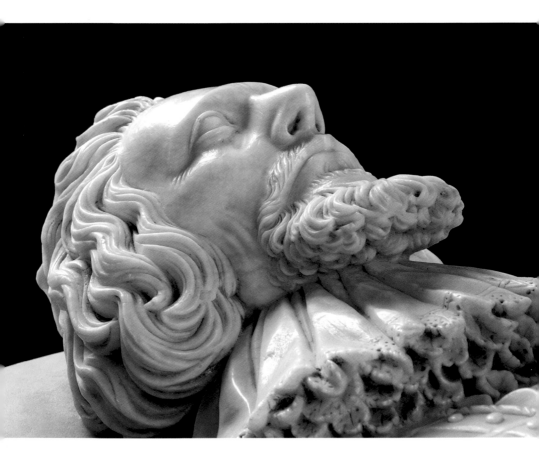

FORWARD THE GREYS

❖

Gaddesby, Rutland

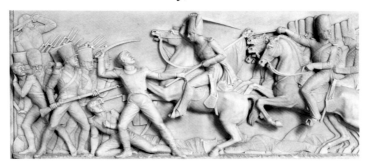

Gaddesby in Rutland has what is reputed to be the only equestrian church monument in England: *To the memory of Edward H. Cheney C.B. Colonel In The Army Late Of The Scots Greys,* who at one time was lord of the manor here. Four horses were shot away from beneath him at Waterloo; on his monument you can see the fourth going down, a bullet hole in its breast. It stood originally in Gaddesby Hall and was trundled down to the church on rollers when the big house was sold. On this page, on a panel fronting the monument, a British soldier fights a mounted French Hussar for the colours.

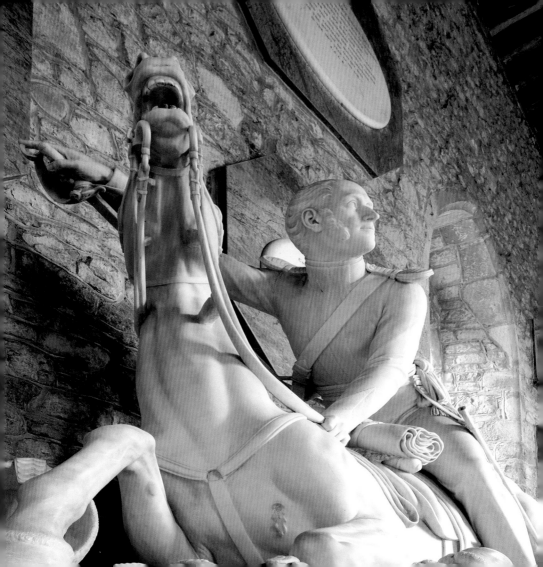

My thanks go the the Deans and Chapters of all the cathedrals whose treasures are featured in this book, and likewise to all the vicars, vergers and enthusiastic helpers who gave me so much assistance. Draughty churches and chapels were opened up to me, and many people, who obviously love their churches, went to great lengths to light my way in the darkness. Many, many thanks go to my fellow church-crawlers who pointed me the way to so much magnificance. I offer this book as my thanks to all the above and to the men and women who created such great art to the glory of their God.

The cameras used were Nikons: an F90 in the good old days of film and, more recently, a Nikon D2X. I used a variety of lenses, from ultra wide angle to a 600mm telephoto. For difficult lighting conditions I used a small hand-held video light.

The children here are on a tomb in Wiggenhall, Norfolk. The painting facing is in Adderbury, Gloucestershire. The Latin inscription above the tomb reads: 'Even tombs meet their end.'